Heraldry in Northern Canada:
First Edition

Jonathan Eliuk

Copyright © 2019 Jonathan Eliuk, independently published

All rights reserved.

The information provided in this book is for general informational purposes only. No representations or warranties are expressed or implied about the information, products, services, or related graphics contained in this book for any purpose.

No part of this publication may be reproduced or transmitted in any form or by any means, electronic or mechanical, without written permission from the author.

ISBN:9781092161916

ACKNOWLEDGMENTS

Thank you all for your support in helping bring this project to completion.

TABLE OF CONTENTS

THE INTRODUCTION OF HERALDRY IN NORTHERN CANADA ... 1

1. ESCUTCHEON ... 5

 1.1. STANDARD .. 5
 1.2. ROUND .. 5
 1.3. AMAUTI ... 6
 1.4. TLINGIT COPPER SHIELD 6

2. CREATURES ... 7

 2.1. DOGS ... 7
 2.1.1 MALAMUTE ... 7
 2.1.2. HUSKY ... 8
 2.1.3. CANADIAN INUIT DOG 8
 2.2. SQUIRREL ... 8
 2.3. NARWHAL .. 8
 2.4. ARCTIC FOX/ARCTIC WOLF 10
 2.5. CARIBOU .. 10
 2.6. WHITE HORSE .. 12
 2.7. WOLF-RAVEN ... 12
 2.8. SNOW BUNTING ... 12
 2.9. MOUNTAIN GOAT .. 12
 2.10. DALL SHEEP .. 13
 2.11. RAVEN .. 13
 2.12. WOOD BISON .. 14
 2.13. WHOOPING CRANE .. 14
 2.14. PINE MARTEN ... 14

- 2.15. Grizzly Bear .. 14
- 2.16. Rock Ptarmigan .. 15
- 2.17. Ring Seal ... 15
- 2.18. Muskox .. 16
- 2.19. Polar Bear ... 16
- 2.20. Walrus ... 17
- 2.21. Arctic Loon ... 17
- 2.22. Arctic Char .. 17
- 2.23. Bowhead Whale .. 18

3. MINERALS .. 21

- 3.1. Gold .. 21
- 3.2. Diamond ... 22
- 3.3. Copper .. 22
- 3.4. Gemstone .. 22

4. GEOGRAPHY .. 23

- 4.1. Snow ... 23
- 4.2. Ice ... 24
- 4.3. Water .. 24
- 4.4. Mountains ... 26
- 4.5. Tree line/Trees .. 26
- 4.6. Hudson Bay .. 27
- 4.7. Cabin .. 27

5. GUIDANCE .. 29

- 5.1. North Pole .. 29
- 5.2. North Star .. 29
- 5.3. Inuksuk ... 30
- 5.4. Wheel ... 31

- 5.5. COMPASS .. 31

6. INDIGENOUS ELEMENTS 33
- 6.1. ULU .. 33
- 6.2. QULLIQ .. 34
- 6.3. IGLOO .. 35
- 6.4. SNOW KNIFE .. 36
- 6.5. TATTOO ... 36
- 6.6. BEADWORK .. 37
- 6.7. PARKA HOOD ... 37
- 6.8. INUKSUK ... 38
- 6.9. DOUBLE-TAILED BEAVER 38
- 6.10. TLINGIT COPPER SHIELD 38
- 6.11. MÉTIS SASH ... 38
- 6.12. SEDNA (NULIAJUQ) ... 39
- 6.13. QILAUTIK (INUIT DRUM) 39
- 6.14. INUIT MAN ... 39
- 6.15. EAGLE ... 40
- 6.16. TREATIES ... 40
- 6.17. CREE BELIEFS ... 40
- 6.18. TIPIS ... 41
- 6.19. AMAUTI .. 41

7. FLORA .. 43
- 7.1. ARCTIC POPPIES .. 43
- 7.2. FIREWEED .. 43
- 7.3. ARCTIC HEATHER ... 44
- 7.4. PURPLE SAXIFRAGE .. 45
- 7.5. MOUNTAIN AVENS .. 45
- 7.6. CLOVER .. 46

- 7.7. Fleur-de-lis .. 46
- 7.8. Grass ... 47
- 7.9. Arctic Cotton ... 47
- 7.10. Arctic Draba ... 48

8. SKY IMAGERY ... 49

- 8.1. Midnight Sun .. 49
- 8.2. Northern Lights 50
- 8.3. Azure Tincture (Blue Colour) 50
- 8.4. North Star ... 51

9. MOTTOS .. 53

- 9.1. Nunavut, Our Strength 53
- 9.2. Many Things in a Small Place 53
- 9.3. Love, Family, Tenacity 53
- 9.4. I Will Show the Way 54
- 9.5. Family is the Bedrock 54
- 9.6. Laughter Heals All 54
- 9.7. Weaving for a Better Tomorrow 54
- 9.8. Fortune Favours the Bold 55
- 9.9. Perseverance, Commitment, Service .. 55
- 9.10. Never Say Die .. 55
- 9.11. Born to Soar ... 55
- 9.12. Co-operation Enhances Peace 56
- 9.13. Let Us Move Forward 56
- 9.14. Let Right Be Done 56
- 9.15. Healing One Heart at a Time 57
- 9.16. Nurture Hope .. 57
- 9.17. My Past Guides My Future 57
- 9.18. Creating Opportunities 57

10.	**TINCTURES**	**59**
	10.1. Copper	59
	10.2. Establishments	59
	10.3. Or	60
	10.4. Azure	60
11.	**FINAL THOUGHTS**	**61**
BIBLIOGRAPHY		**63**

The Introduction of Heraldry in Northern Canada

The history of heraldry in Canada is an interesting one.

Until 1988, the granting of arms in Canada had been an exercise of the College of Arms in London, England, or the Court of the Lord Lyon in Edinburgh, Scotland, but since then it has been exclusively the domain of the Canadian Heraldic Authority. Canada was the first country in the Commonwealth to have its own Heraldic Authority, a proud achievement in the advancement of heraldry in Canada. Today, the Canadian Heraldic Authority is administered by officers, known as heralds of arms, appointed by the Governor General of Canada.

Although the system of armorial design and display comes to Canada primarily from England and France, the elements present in various designs represent the many cultures that helped build Canada into the nation it has become. Canadian heraldry features interesting and beautiful designs depicting Canada's rich history. There is no artwork more interesting than the heraldry of Northern Canada. As heraldry is relatively new in Northern Canada, this has given

the region and its people the opportunity to use never-before-seen design elements in their heraldic achievements—the full display of all heraldic components, including the crest, escutcheon, motto, and supporters. Northern Canadian heraldry presents the history and people of Northern Canada as unique parts of our nation.

Defined by Canada's three Territories—Yukon, Northwest Territories, and Nunavut—Northern Canada is comprised of four million square kilometres of land and water, accounting for about 40% of Canada's total area. This vast region is inhabited by only 113,604 people, according to the 2016 Canadian census; Northern Canada is sparsely populated, and each disparate community is thus able to develop its own customs free from much outside interference. This makes the artwork and heraldry of the region unique, as the inhabitants are able to develop their own style of heraldic achievement.

This book is an attempt to catalogue and describe the different elements of the achievements of Northern Canada as they relate to its people and geography. In its pages, I will try to identify elements that are unique to the region and the significance that they have. Like no other people, Northern Canadians tell their stories through achievements that Canada has never seen before. I have also included a bibliography at the end of this book so that you may read further about this fascinating aspect of heraldry. I hope that you enjoy this book and take out of it what I enjoyed putting into it.

For each component described in this book, I have tried my

best to research the reason why it is used and what it represents. For those elements I could not find a definitive answer, I have used the best artistic interpretation possible to draw a conclusion from the artwork. I am not an expert in heraldry, nor do I have any formal education on the subject. Whenever the term "Register" is used, it refers to the Governor General of Canada's Public Register of Arms, Flags and Badges (https://www.gg.ca/en/heraldry/public-register-arms-flags-and-badges-canada). This book is meant to be a primer in the heraldry of Northern Canada and its different components

1. Escutcheon

1.1. Standard

The standard escutcheon, such as that used in the Canadian coat of arms, is used predominantly in Yukon and the Northwest Territories—most notably in those territories' achievements. It is also used in the achievements of various municipalities and territorial Commissioners.

1.2. Round

A round escutcheon features prominently in the coats of arms of the Inuit people. According to the Register entry for the coat of arms of the former Commissioner of Nunavut, Peter Irniq, "the circular shield is an important shape culturally, indicating, among other things, the circle of life and the head of a drum." Anecdotally, seeing this shape in the Nunavut coat of arms on the doors to the Senate Chamber on Parliament Hill, I asked a tour guide about it and was told that the traditional escutcheon shape had not been used because sharp points, such as those found at the edges of a shield, were considered a bad omen—though I have not been able to confirm this story. The coats of arms of the Nunavut territory as well as of various

Commissioners of Nunavut and several corporations based in Nunavut have this shape.

1.3. Amauti

The amauti is a traditional Inuit women's garment, used to carry infants to prevent freezing, though providing a breathability of the fabric for both mother and child. The escutcheon based on the amauti has a flat top, then sharply turns down and inward and then back outward one-third of the way down into outward facing points on either side, before coming back in and moving down toward a u-shaped bottom. This design has made it to the coat of arms of Nellie Taptaqut Kusugak, the current Commissioner of Nunavut. An escutcheon in the shape of an amauti is meant to symbolize Kasuguk herself according to the Register.

1.4. Tlingit Copper Shield

Please see the section on Indigenous Elements.

2. Creatures

Like heraldry of other parts of the world, the heraldry of Northern Canada depicts animals that are native to the region. Their uniqueness is a testament to what Northern Canada has to offer in terms of artwork and heraldry.

2.1. Dogs

2.1.1 Malamute

The crest of the coat of arms of Yukon is an Alaskan malamute. As a breed native to Alaska, as well as Yukon, and first trained by the Inupiaq people of the Norton Sound region, the malamute shows resilience in Arctic conditions and can be seen as a representation of the endurance of the people of Yukon. Moreover, its depiction there celebrates its role in Yukon history. According to the Encyclopedia Britannica, the malamute "was widely used in the opening of the mineral-rich Yukon territory to European habitation." Also, the Royal Canadian Heraldic Society indicates that "from the earliest days of exploration, the strong and quick Malamute played an important role in opening up the Territory to settlement." The Alaskan

malamute also appears as a supporter in the coat of arms of the former Commissioner of the Northwest Territories, Daniel Leonard Norris

2.1.2. Husky

A husky is depicted on the crest of the coat of arms of the former Commissioner of Yukon, Geraldine Van Bibber. According to the Register, it is said to represent "strength and ability to withstand the harsh, cold environment of the North."

2.1.3. Canadian Inuit Dog

The Canadian Inuit dog is depicted as supporters in the coat of arms of the NCC Investment Group, incorporated in Iqaluit, Nunavut, where it most likely symbolizes their presence in Nunavut, as the "Canadian Inuit dog is an official emblem of Nunavut," according to the Register.

2.2. Squirrel

In the roundel over the Cross of St. George of the coat of arms of Yukon, there is a depiction of vair, or squirrel hair. This has been included to represent the abundance of fur bearing animals in the area. According to Heritage Canada, even "the Cross of St. George at the top of the shield refers to the early explorers and fur traders from England."

2.3. Narwhal

This symbol appears in multiple achievements in Northern Canadian heraldry. The crest of the coat of arms of the Northwest Territories, for instance, depicts two golden

narwhals. The narwhal is also featured as a supporter in the coat of arms of Nunavut. According to Kara Rogers, writing in the Encyclopedia Britannica,

> Folklore surrounding the narwhal is rooted in cultural and natural history. For instance, among the Inuit, an indigenous people of the Arctic, narwhals have long been hunted for food and for the ivory of their tusks. But the Inuit also have a legend about how the narwhal and its tusk came to be. According to the story, a cruel woman was persuaded by her son to tie the end of a harpoon rope around her waist. When he threw the weapon and successfully struck a large whale—which he had deliberately aimed to hit—she was pulled into the ocean. There, in the dark depths, she became a narwhal and bore a tusk formed from her hair, which had become twisted around the rope.

The animal is so prominent in Northern Canadian culture that the Mace of the Legislative Assembly of Nunavut is made from a narwhal tusk.

Narwhals also appear as supporters in the coat of arms of the former Commissioner of the Northwest Territories, Daniel Joseph Marion. In this case, according to the Register, "the narwhals allude to the crest of the Northwest Territories, of which Mr. Marion was the 13th Commissioner from 1999 to 2000."

Narwhals are also represented in the coat of arms of Nunasi Corporation in Iqaluit in the form of narwhal tusks being held by the supporters. The Register gives the following description of its inclusion: "The qilalugaq tugaalik, or narwhal, represented here by its tusk, has been harvested by the Inuit for meat and ivory for over a thousand years."

2.4. Arctic Fox/Arctic Wolf

The coat of arms of the Northwest Territories has a depiction of the face of an Arctic fox on the shield. The Arctic fox is prominent in Northern Canada and changes the colour of its fur in the winter to match its snowy surroundings.

The coat of arms of Helen Mamayaok Maksagak, the former Commissioner of the Northwest Territories depicts an Arctic wolf as one of the supporters. The Register notes that the supporters are intended to show the variety of wildlife that is contained in the Northwest Territories.

A wolf is also represented as a supporter in the coat of arms of the former Commissioner of Yukon, Judy Gingell.

2.5. Caribou

The caribou has a prominent place in Northern Canadian culture, as well as throughout the nation. The caribou is featured on the reverse of the current 25-cent coin in Canada. It is also featured in Northern Canadian heraldry as a supporter in the coat of arms for Nunavut. This heraldic support can be seen as symbolic, as the caribou has supported the Inuit people as a source of nourishment.

A caribou is also depicted as a supporter on the coat of arms of Helen Mamayaok Maksagak, the former Commissioner of the Northwest Territories. The Register also notes the symbolic significance of the caribou here, as a provider of food in Inuit culture. The caribou's symbolic significance is noted in descriptions of several coats of arms.

Caribou are also used as supporters in the coat of arms of the former Commissioner of Yukon, Geraldine Van Bibber. The Register states that "the Gwich'in life and culture have traditionally been based on the caribou herd of the Porcupine River area."

The animal can also be found in the coat of arms of the former Commissioner of the Northwest Territories, George Lester Tuccaro. The Register indicates that it included because "the caribou represent a traditional source of sustenance."

There is a caribou in the crest of the coat of arms of the former Commissioner of the Northwest Territories, Daniel Joseph Marion. According to the Register, "the caribou is an important animal in the Northwest Territories."

Caribou antlers are also prominent in the coat of arms of the former Commissioner of Nunavut, Edna Agnes Elias. The Register mentions that "the antlers allude to the caribou, one of the staple food sources of the Inuit."

Caribou are featured as supporters in the coat of arms of Nunasi Corporation in Iqaluit, Nunavut. The Register notes that their inclusion celebrates the caribou as "an important source of food, clothing, shelter, and tools for the Inuit."

2.6. White Horse

In a clever bit of wordplay, one of the supporters in coat of arms of the Municipality of Whitehorse is a white-coloured horse. The city was named after the White Horse Rapids in Yukon. The name of the municipality was originally two separate words but was eventually amalgamated into one word.

2.7. Wolf-Raven

This creature is depicted in the coat of arms of Whitehorse as a supporter and represents and honours the two clans of First Nations groups in the city.

The wolf-raven also makes an appearance as supporters and on the coat of arms of the former Commissioner of Yukon, John Kenneth McKinnon. This is assumed to be an ode to the City of Whitehorse, where he spent much of his administration as Commissioner serving the public.

2.8. Snow Bunting

The snow bunting is a small bird that thrives in Arctic conditions. Surviving on a diet of mostly seeds and insects, its breeding grounds are located predominantly in the geographical area of Nunavut. It is represented as supporters in the coat of arms of Nellie Taptaqut Kusugak, the current Commissioner of Nunavut.

2.9. Mountain Goat

The mountain goat is native to the Rocky Mountain region of North America. It is unique among animals as it has the ability to climb steep terrain with ease and can survive

colder climates. The mountain goat is represented in the coat of arms of the current Commissioner of Yukon, Douglas George Phillips. The Register describes its inclusion as a nod to the Phillips's love of mountaineering. As the mountain goat is an inhabitant of Yukon, it is no surprise that this is included in his achievement.

2.10. Dall Sheep

Dall sheep (also Dall's sheep) are located in Yukon and British Columbia. There are currently about 20,000 Dall sheep in Yukon, making them a native inhabitant. According the Yukon Department of the Environment, "Dall's Sheep have long been prized for their delicious meat. First Nations would traditionally hunt sheep with bow and arrows or set snares along frequented travel routes. Sheep fleece was used to make blankets, jackets, and winter pants and horns used for ladles and dishes." This animal is depicted in the coat of arms of the current Commissioner of Yukon, Douglas George Phillips. The Register describes its inclusion as a nod to the Phillips's love of mountaineering.

2.11. Raven

According to the Yukon Government, "the raven was adopted as Yukon's official bird in 1985 and it is seen everywhere in Yukon. It is a very intelligent bird and an opportunistic feeder, feasting on everything from carrion to groceries left in the back of pick-up trucks." The raven is depicted as a supporter in the coat of arms of the former Commissioner of Yukon, Judy Gingell. I assume that this is an ode to Yukon, where she assumed office.

2.12. Wood Bison

Wood bison are depicted as supporters in the coat of arms of the former Commissioner of the Northwest Territories, Anthony Wilfred James Whitford. According to the Government of Canada, "there are herds of wood bison in Alberta, Manitoba, British Columbia, Yukon, and southwestern Northwest Territories." According to the Register, "The wood bison is found near his birthplace, Fort Smith, Northwest Territories."

2.13. Whooping Crane

The breeding ground of the whooping crane is the southern portion of the Northwest Territories. The whooping crane is featured on the crest of the coat of arms of the former Commissioner of the Northwest Territories, Anthony Wilfred James Whitford. According to the Register, "the whooping crane refers to the gentleness, wisdom and grace of his late wife Elaine, from whom Mr. Whitford received much guidance."

2.14. Pine Marten

According to the Yukon Department of the Environment, the marten lives in Northern Canada, throughout Yukon, and prefer boreal habitats. A pine marten is depicted in the crest of the coat of arms of the former Commissioner of the Northwest Territories, Daniel Leonard Norris.

2.15. Grizzly Bear

According to the Canadian Wildlife Foundation, the Grizzly Bear is native to northwestern North America, with a habitat in Yukon and the Northwest Territories. A grizzly

bear is depicted as a supporter in the coat of arms of the former Commissioner of the Northwest Territories, Daniel Leonard Norris, and may there be a reference to the natural habitat of grizzly bears being in Yukon and the Northwest Territories. Due to its large size and strength, a grizzly bear may have been used to show strength in the Northwest Territories and the prominence of Mr. Norris' position as Commissioner.

2.16. Rock Ptarmigan

According to the Canadian Wildlife Federation, "the Rock Ptarmigan and the Willow Ptarmigan are found in all countries ringing the North Pole." This makes the rock ptarmigan native to Nunavut. Citing the same source, they are also known to be mass travelers as "Rock Ptarmigans, particularly those from northern Ellesmere Island, are the champion nomads of the grouse world, and their migrations can exceed 800 km." The rock ptarmigan is depicted on the crest of the coat of arms of the former Commissioner of Nunavut, Ann Meekitjuk Hanson. It should also be noted that "the rock ptarmigan is the official bird of Nunavut," according to the Register.

The bird is also featured on the coat of arms of the NCC Investment Group, incorporated in Iqaluit, Nunavut. This was most likely included to establish their presence in Nunavut.

2.17. Ring Seal

According to National Geographic, the ring seal inhabits the circumpolar regions of the North. According to the Register, "the seal is important for Inuit life as a source of

food, clothing, and oil." The ring seal is depicted on the coat of arms of the former Commissioner of Nunavut, Ann Meekitjuk Hanson, where it appears as a supporter, presumably a nod to the seal's endurance in northern climates.

A ring seal is also used as a supporter in the coat of arms of the former Commissioner of Nunavut, Peter Irniq. The Register indicates that this was to represent the sea life of Nunavut.

The ring seal is also featured as a supporter in the coat of arms of the former Commissioner of Nunavut, Edna Agnes Elias. The Register also indicates that the ring seal is a staple food of the Inuit and was included as a supporter due its importance in Inuit culture.

2.18. Muskox

According to the Canadian Wildlife Federation, "The muskox *Ovibos moschatus* lives on Canada's arctic tundra. Superficially the muskox resembles the bison: humped shoulders and a long black coat accentuate the shortness of its legs. In fact, it is more closely related to sheep and goats." The muskox is an animal that thrives in Northern Canadian arctic climates. It is no surprise that this mighty animal is found in the coat of arms of the former Commissioner of Nunavut, Peter Irniq, as a supporter. The Register indicates that its presence there represents the land life of Nunavut.

2.19. Polar Bear

According to the Government of Canada, polar bears live in

the Arctic climates in the Northern coasts of the world. A person's mind immediately thinks of Northern Canada when the image of the polar bear is conjured. It is even represented by the Royal Canadian Mint on the reverse of the current Canadian $2.00 coin. The polar bear is represented in the coat of arms of the Bishopric of Yukon. It is assumed that the polar is representative of Northern Canada in general, as polar bears are not native to Yukon with the exception of the coastal region.

2.20. Walrus

The walrus is found in coastal regions of Northern Canada. According to the Royal Canadian Geographic Society, "the largest walrus herd in Canada occurs in Foxe Basin, where numerous polynyas (areas of open water surrounded by pack ice) create a desirable habitat." A walrus can be found on the crest of the coat of arms of Grégoire Daniel Cayen of Iqaluit, Nunavut. According to the Register, "the walrus is a majestic creature which here represents the natural beauty and fortitude of the far north."

2.21. Arctic Loon

The Arctic loon is an inhabitant of Northern Canada and lives in open tundra, according to the Audubon Society. This animal is depicted on the crest of the coat of arms of the former Commissioner of Nunavut, Edna Agnes Elias. The Register indicates that the reason for its inclusion was that it is Elias's favourite bird.

2.22. Arctic Char

The Ministry of Fisheries and Oceans states the following

about Arctic char:

> Arctic Char are distributed across the Canadian Arctic Ocean including around the islands of the Arctic Archipelago. While this species may also be found in many rivers and lakes located in Canada's Far North, the sea-run Arctic char are the most sought after for food and commercial uses.
>
> Arctic char are an important cultural, subsistence and economic resource in the Arctic. There are a number of commercial fisheries taking place in the ocean tidal waters and river waters, as well as many subsistence fisheries for Canada's Inuit.
>
> Arctic char are a highly priced delicacy, marketed mainly fresh and frozen as whole-dressed fish and steaks. A small quantity is also processed into value–added products including smoked char and jerky.

Due to their prominence in Northern Canadian culture, they also make an appearance in heraldry. They are represented in the coat of arms of the former Commissioner of Nunavut, Edna Agnes Elias. In addressing their inclusion, the Register states that the Arctic char is a staple food source for the region.

2.23. Bowhead Whale

According to the World Wildlife Federation, the bowhead

whale is a year-round species in the Arctic that were hunted for whale oil and baleen. The bowhead whale, due to its significance in Northern Canadian history has been included in Northern Canadian heraldry in the coat of arms of Nunasi Corporation in Iqaluit, Nunavut. According to the Register, "the bowhead whale, known as the Arctic whale, has been hunted for centuries by the Inuit for its blubber, meat, oil, bones and baleen."

3. Minerals

Much of the development of Northern Canada is associated with the extraction of minerals, so it is no surprise that various minerals have found their way into the heraldry of Northern Canada. The coat of arms of the Municipality of Yellowknife displays a pickaxe and shovel as an ode to the importance of the mining and mineral industry in the area.

3.1. Gold

The discovery of gold has led to the development of several regions of Northern Canada.

Gold is depicted in the Yukon coat of arms as "two bezants [gold coins] in pale." In the coat of arms of the current Commissioner of Yukon, Douglas George Phillips. According to the blazon (the formal description), the chevron base is gold, and the "gold mountain" represents the natural gold deposits that are found in Yukon.

Gold is also represented in the coat of arms of the Northwest Territories, with two golden narwhals in the crest and golden billets to represent the vast resources of the region. According to Heritage Canada, "Minerals and fur, the foundation of northern wealth, are represented by

gold billets in the green section of the shield." It is also interesting to note this "nugget" of knowledge about gold in the region: according to Heritage Canada, "in 1981, gold was proclaimed as the mineral emblem for the Northwest Territories." Historically, gold has played a major role in the development and prosperity of the area. It symbolizes the enduring value of wealth and the bright prospects and future of the Northwest Territories.

3.2. Diamond

While not part of heraldry per se, the Municipality of Yellowknife has a trademarked phrase and image that relates to diamonds.

3.3. Copper

The coat of arms of Whitehorse contains a tincture of a copper colour to represent the importance of the copper industry in the region as well as its use by Indigenous groups.

3.4. Gemstone

There are gemstones found in the coat of arms of the former Commissioner of the Northwest Territories, George Lester Tuccaro. The Register suggests that this is representative of Tuccaro's children and grandchildren, but it can also be seen to represent the abundance of minerals found in the Northwest Territories

4. Geography

The geography of Northern Canada is varied, from the Rocky Mountain range of Yukon and the boreal forests of the Northwest Territories to the Arctic regions of Nunavut. These geographical regions are also depicted in the achievements of Northern Canada. In addition to specific elements, geography is also depicted overall in achievements. For instance, the compartment—the design under escutcheon—of the coat of arms for the City of Whitehorse contains "a stylisation of the City's natural setting, with the rocks and conifers of the surrounding mountains," according to the Register.

4.1. Snow

It is no surprise that snow has its place in Northern Canadian heraldry, as it is commonplace and a part of the lifestyle of Northern Canadians. It is depicted in several components of heraldic achievements.

On the crest of the coat of arms of Yukon, the Alaskan malamute is standing on a mound of snow. The white on the coat of arms of the Northwest Territories depicts a snowy icepack through the Northwest Passage.

On the coat of arms of Helen Mamayaok Maksagak, the former Commissioner of the Northwest Territories, snow is depicted in the compartment and is described by the Register as being part of the natural landscape.

Snow is also depicted in the compartment of the coat of arms of the former Commissioner of the Northwest Territories, Glenna Fanny Hansen. The same can be said about the coat of arms of the former Commissioner of Nunavut, Peter Irniq.

It is also used in the coat of arms, under the supporters, of the NCC Investment Group, incorporated in Iqaluit, Nunavut. According to the Register, this was included because it "represents the geography of Nunavut."

4.2. Ice

An iceberg is featured in the compartment of the coat of arms of Nunavut. Ice is also featured as white in the coat of arms of the Northwest Territories, depicting the ice in the Northwest Passage.

Pack ice is also present in the compartment of the coat of arms of the Nunasi Corporation in Iqaluit, Nunavut. This "represents the geography of Nunavut," according to the Register, and was likely included to represent their presence in Nunavut.

4.3. Water

On the coat of arms of Yukon, the wavy white lines are representative of the Yukon River. The shield of the coat of arms of Whitehorse also depicts a paddlewheel steamboat

on a body of water. The coat of arms of the Northwest Territories has a blue wavy line on the shield depicting the Northwest Passage.

Open water is also represented in the coat of arms of Helen Mamayaok Maksagak, the former Commissioner of the Northwest Territories, in the form of wavy blue lines. The Register states that these lines in the compartment "refer to the dominant characteristics of the northern landscape."

Water is also depicted in the coat of arms of the current Commissioner of Yukon, Douglas George Phillips, shown as wavy lines under the compartment. According to the Register, this was included to show the territorial landscape as well as Phillips's love of fishing.

Wavy bars also represent water in the coat of arms of the former Commissioner of Yukon, Geraldine Van Bibber. According to the register, "the wavy bars represent the rivers in Yukon as well as never-ending life."

A river is also depicted in the coat of arms of the former Commissioner of the Northwest Territories, Anthony Wilfred James Whitford. According to the Register, "the white wavy strip represents the river running from south to north in the territory and alludes to the name 'Whitford' because a ford always requires a river."

There is also a depiction of water in the form of wavy lines in the compartment of the coat of arms of the former Commissioner of Nunavut, Ann Meekitjuk Hanson. And wavy lines in the compartment of the coat of arms of the former Commissioner of Nunavut, Peter Irniq, also

represent water.

There are two wavy bars representing the Mackenzie River in the compartment in the coat of arms of the former Commissioner of the Northwest Territories, George Lester Tuccaro.

4.4. Mountains

In the coat of arms of Yukon, the shield contains "two piles reversed Gules" to represent the mountains of the region. As Yukon sits in the Rocky Mountain region, this beautiful area of sharp peaks has been depicted in the Yukon coat of arms.

Mountains are also depicted in the coat of arms of the city of Whitehorse. According to the Register, "the sawtooth upper edge of the crown is a symbolic reference to the hills surrounding Whitehorse."

Mountains are also present in the compartment of the coat of arms of the current Commissioner of Yukon, Douglas George Phillips. According to the Register, this was included to show the natural landscape of Yukon as well as the Phillips's love of mountaineering. The base of the chevron of the arms depicts the mountains.

4.5. Tree line/Trees

The coat of arms of the Northwest Territories depicts the tree line between the boreal forest and the tundra by a wavy line between the green representation of the boreal forest and the red to represent the Arctic tundra. This may also account for why the mask of the Arctic fox is prominent

over the red portion of the shield, indicating its natural habitat. This tree line pattern is also visible in the coat of arms of the former Commissioner of the Northwest Territories, Anthony Wilfred James Whitford.

Trees are also depicted in the compartment of the coat of arms of the Municipality of Whitehorse.

Trees are also depicted in the coat of arms of the current Commissioner of Yukon, Douglas George Phillips, as "per chevron in chief barry-sapiné Vert and Argent" (stacked triangles in green to look like evergreen trees), according to the blazon. According to the Register, "the tree pattern represents Commissioner Phillips's love of the outdoors and his commitment to wildlife conservation."

Pine trees are also represented in the coat of arms of the Bishopric of Yukon. It is assumed that this represents the abundance of this form of life in the Territory, as the vast majority of Yukon sits below the tree line.

4.6. Hudson Bay

There are waves depicted on the coat of arms of Nellie Taptaqut Kusugak, the current Commissioner of Nunavut. These waves represent Hudson Bay and her home at Rankin Inlet, according to the Register. Hudson Bay is located in Northern Canada and is home to such coastal cities in Nunavut such as Arviat, Whale Cove, and Chesterfield Inlet.

4.7. Cabin

As part of the geography of Northern Canada, cabins can

be found scattered all over the region and provide shelter from the elements during extended excursions in the outdoors. A cabin can be found on the crest of the coat of arms of the current Commissioner of Yukon, Douglas George Phillips. The Register states that this is in reference to his love of the outdoors.

5. Guidance

Guidance and navigation is a common theme in the heraldry of Northern Canada. Both man-made and natural constants that provide guidance in the harsh terrain of Northern Canada are represented in the region's heraldry. I have described some examples of this below.

5.1. North Pole

The crest of the coat of arms of the Northwest Territories has a depiction of a compass rose. This is a representation of the home of the magnetic North Pole. When the coat of arms was granted by Queen Elizabeth II in 1956, the geomagnetic North Pole was located on Ellesmere Island, which was part of the Northwest Territories at the time. As of the date of this publication, the geomagnetic North Pole currently lies in Nunavut.

5.2. North Star

The North Star is also featured in the coat of arms of Nunavut. According to the Legislative Assembly of Nunavut, "The star is the *Niqirtsuituq*, the North Star and the traditional guide for navigation and more broadly, forever remains unchanged as the leadership of the elders in the community."

The North Star is also featured in the crest of the coat of arms of Nunasi Corporation in Iqaluit, Nunavut. The Register describes this best. "The star is the *Niqirtsuituq*, the North Star and the traditional guide for navigation. In the North, it is a symbol of permanence, and connects to the idea of leadership exercised by the elders in the community."

5.3. Inuksuk

The coat of arms of Nunavut also features an *inuksuk,* a monument made of stone used to provide guidance and direction. The *inuksuk* is also used to mark sacred spaces and other points of significance. As a guidance device used by the Inuit people, in heraldry it may be seen as a guide to responsible government in the Legislative Assembly. The *inuksuk* can also be used as a symbol of creation and stability, another reference to guidance. According to the Registrar for the coat of arms of Nellie Taptaqut Kusugak, the current Commissioner of Nunavut, "the inuksuk, a symbol of Nunavut, refers to her late husband Jose and his role in the creation of the territory."

An *inuksuk* is also used in the coat of arms of Helen Mamayaok Maksagak, the former Commissioner of the Northwest Territories. According to the Register, the purpose of the *inuksuk* in the arms is to "convey through a visual message her function as a community leader and as a guide or stable point of reference in a changing world." This further emphasizes the guidance principle that the *inuksuk* holds in Northern Canadian heraldry.

It is also depicted on the coat of arms of the former

Commissioner of Nunavut, Peter Irniq. In this case, it is also representative of guidance, according to the Register, which notes that "the central stone of the inukshuk is a long horizontal, which refers to moving forward or the way ahead." The *inuksuk* is a symbol of guidance in Northern Canadian heraldry.

5.4. Wheel

The wheel is depicted in the coat of arms of the Municipality of Whitehorse and symbolizes the city as the hub of transportation. Again, the foundation of a "hub" that all can rely on is another example of the guidance motif in Northern Canadian heraldry.

5.5. Compass

A compass rose is featured in the coat of arms of Mark Murray De Weerdt from Yellowknife. It is assumed that this also relates to the symbolism of guidance in Northern Canadian heraldry.

6. Indigenous Elements

According to the 2006 Canadian census, about 60% of the Inuit people live in Northern Canada. This large contingent of Indigenous Canadian have made an impact on the region's culture and lifestyle. Many elements that are depicted in Northern Canadian heraldry, such as the igloo and qulliq, are larger representations of family, community, and unity. The theme of family and Inuit elements in heraldry go hand in hand. There are many examples to draw from in Northern Canadian heraldry.

6.1. Ulu

The ulu is a tool used by Inuit women for scraping and preparing food. An ulu appears in the coat of arms of Nellie Taptaqut Kusugak, the current Commissioner of Nunavut. According to the Register, "the ulus, used as knives or scrapers by Inuit women, represent her three daughters, Aliisa, Alaana and Special." In this case, the ulu represents the vital role that women play in the Inuit community.

An ulu also appears in the crest of the coat of arms of Helen Mamayaok Maksagak, the former Commissioner of the Northwest Territories. The Register also describes how the ulu represents the female archetype provider to the

community and that "it also symbolizes the many ways in which food, shelter and clothing are provided."

The ulu can also be found in the crest of the coat of arms of the former Commissioner of the Northwest Territories, Glenna Fanny Hansen. It is noted in the Register that the ulu is "an important symbol of the Inuvialut way of life."

An ulu can also be found on the supporters of the coat of arms of the former Commissioner of Nunavut, Edna Agnes Elias. The Register here gives the description of the ulu as "another traditional tool of survival."

6.2. Qulliq

A qulliq is an oil lamp that was traditionally used by the Inuit people. This oil lamp would be fueled by seal fat or blubber and could be used for either cooking or heating. When in use, the lamp is smokeless, and thus it can be used in an enclosed igloo. It is a powerful and enduring symbol of Inuit utility in surviving the harshest climates on Earth. Even today, there is a utility company in Nunavut named after the qulliq lamp. The qulliq is depicted in the coat of arms of Nellie Taptaqut Kusugak, the current Commissioner of Nunavut. The qulliq is also depicted in the coat of arms of Nunavut. According to the Register, the qulliq "represents light and the warmth of family and the community."

The qulliq is also on the coat of arms of the former Commissioner of Nunavut, Ann Meekitjuk Hanson. The Register describes is the lamp as "an important object of Inuit culture that appears in the coat of arms of Nunavut. It

was traditionally kept by the women, and provided light, warmth, and a source of cooking and melting water. It is still used as a ceremonial item."

The qulliq is also featured in the coat of arms of the former Commissioner of Nunavut, Edna Agnes Elias. The Register indicates that this is a "traditional tool (that) represents survival."

The lamp is also featured in the crest of the coat of arms of the NCC Investment Group Incorporated in Iqaluit, Nunavut. According to the Register, "the quliq represents light and the warmth of family and the community, which are important to the NCC Investment Group."

6.3. Igloo

Igloos are the traditional housing of the Inuit people. It has been a symbol of warmth and community, as a large family would have to live inside for most of the winter months. This symbol is so prominent in Northern Canada that there is a church in the Northwest Territories that is modeled after an igloo. The coat of arms of Nunavut depicts an igloo in the crest. The Register describes the vitality of the igloo for Nunavut, as it "represents the traditional life of the people and the means of survival. It also symbolizes the assembled members of the Legislature meeting together for the good of Nunavut." Again, the igloo is a prominent symbol for the coming together of the community.

The igloo is used to symbolize community in commerce as well, as it features in the coat of arms of the NCC Investment Group, incorporated in Iqaluit, Nunavut.

According to the Register, "it symbolizes the community and the mission of the Group, which is to design, build and lease quality accommodation at a reasonable price."

6.4. Snow Knife

The snow knife is used to carve out blocks of ice for creating igloos for the cold winter months. As the task of carving blocks fell to men, the snow knife has been used as a symbol of masculinity in Northern Canadian heraldry. It is depicted in the coat of arms of Nellie Taptaqut Kusugak, the current Commissioner of Nunavut, to symbolize her son, Pujjuut.

The snow knife is also featured with the supporters in the coat of arms of the NCC Investment Group, incorporated in Iqaluit, Nunavut. This could allude to one of the companies in the NCC Investment Group being involved in construction.

6.5. Tattoo

The Inuit have a history of tattooing. Na'ama Freeman notes that, "traditionally, the tattoos also have a dualistic spirituality. Some believe that a woman who receives a tattoo would have a better afterlife as a result of enduring such horrific pain. Without a tattoo, a woman would be too 'weak' and remain 'underneath,' keeping herself from the luxuries of the afterlife." A tattoo is depicted in the pattern under the motto in the coat of arms of Nellie Taptaqut Kusugak, the current Commissioner of Nunavut. She has this same pattern tattooed on her wrists, according to the Register.

6.6. Beadwork

Beadwork is a significant part of Inuit culture. The art of beadwork grew as trade with Europeans increased in the nineteenth century. Beadwork on the east and west coasts of Hudson Bay had very distinct styles. Beadwork is depicted in heraldry in the coat of arms of Nellie Taptaqut Kusugak, the current Commissioner of Nunavut. It is displayed on the collars of the supporters.

Beadwork is vital in First Nations culture as well. The coat of arms of the former Commissioner of the Yukon, Geraldine Van Bibber, features Gwich'in beadwork on the supporters' collars.

6.7. Parka Hood

The parka hood in Northern Canadian heraldry sometimes takes the place of the helm in standard practice. A parka hood is used as a helm in the coat of arms of Helen Mamayaok Maksagak, the former Commissioner of the Northwest Territories. It is stated in the Register that this was used to celebrate the Maksagak's culture. Presumably, a parka hood would be more practical than a metal helmet in the Arctic climates of the Northwest Territories.

The parka hood is also found in the place of a helm in the crest of the coat of arms of the former Commissioner of Nunavut, Peter Irniq. According to the Register, "instead of the traditional steel helmet of European-style heraldry, the base of the crest is a man's parka hood. The crest refers to His Honour's own spirit and an important part of Inuit culture, while repeating the theme of joy and happiness."

The parka hood can also be seen as having a deeper significance. There is also a parka hood on the coat of arms of the former Commissioner of Nunavut, Edna Agnes Elias. According to the Register, "The hood upon which the crest rests has a wolf fur ruff signifying Inuit reliance on fur-bearing animals for clothing."

6.8. Inuksuk

Please see the section on Guidance.

6.9. Double-tailed Beaver

The double-tailed beaver is depicted on the coat of arms of the current Commissioner of Yukon, Douglas George Phillips. The Register indicates that the double-tailed beaver is "the emblem of the Deisheetaan clan of the Carcross/Tagish First Nation, into which Commissioner Phillips was adopted in 2009."

6.10. Tlingit Copper Shield

The Tlingit people are known to make elaborate and beautiful copper shields with ornate artwork embedded in the shield itself. In a unique twist in Northern Canadian heraldry, a Tlingit Copper Shield is being used as a supporter for the coat of arms of the former Commissioner of Yukon, Judy Gingell. As per the blazon, the supporter consists of "a Tlingit copper proper decorated to include designs representing salmon, crochet hooks and a fishing hook Sable."

6.11. Métis Sash

There is a Métis sash depicted in the coat of arms of the

former Commissioner of the Northwest Territories, Anthony Wilfred James Whitford. Please see the section on Mottos for more details.

6.12. Sedna (Nuliajuq)

Sedna can be found as a supporter in the coat of arms of the former Commissioner of Nunavut, Ann Meekitjuk Hanson. According to the Register, "Sedna (Nuliajuq) is a famous creature from mythology around the circumpolar world, known as the sea ruler of the Arctic." This is also an example of how Indigenous representations in Northern Canadian heraldry can also draw upon Indigenous religions.

6.13. Qilautik (Inuit Drum)

The qilautik is a drum used by the Inuit in drum dancing and is made from Caribou skin. According to the Native Drums Project, "*Imnglinnaqtuq* refers to a person who is drum dancing with only the song, when he is standing in the middle of the singers with the drum and the beater in his hands, but is not making the usual vigorous drum beating and body motions." This is culturally significant to the Inuit and is represented in their arms. A qilautik is represented in the coat of arms of the former Commissioner of Nunavut, Peter Irniq. The Register refers to this element as "an important part of Inuit culture, while repeating the theme of joy and happiness." There is also an Inuit man holding a drum in the crest of the same holder.

6.14. Inuit Man

In the crest of the coat of arms of the former Commissioner of Nunavut, Peter Irniq, there is, according

to the blazon, "A demi Inuit man holding a drum and beater proper." According to the Register, "the crest refers to His Honour's own spirit and an important part of Inuit culture, while repeating the theme of joy and happiness."

6.15. Eagle

The eagle can be found in the crest of the coat of arms of the former Commissioner of the Northwest Territories, George Lester Tuccaro. According to the Register, "the eagle honours the Mikisew Cree, Mr. Tuccaro's heritage from his father."

6.16. Treaties

Treaties established between Canada and the First Nations are also represented in Northern Canadian heraldry. There are two wavy bars, representing the Mackenzie River, in the compartment of the coat of arms of the former Commissioner of the Northwest Territories, George Lester Tuccaro. However, according to the Register, these bars also, more significantly, "allude to the importance of sustainable development and sharing land 'as long as the sun shines, rivers flow and the grass grows', a traditional expression that appears in the treaty declaration signed by the Mikisew Cree in 1898 and also in the 1692 presentation of the Two Row Wampum belt, known as Gustwenta."

6.17. Cree Beliefs

In the coat of arms of the former Commissioner of the Northwest Territories, George Lester Tuccaro, there are supporters of caribou with seven stars. According to the Register, "Cree mythology speaks of their people coming to

Earth from the seven stars in spirit form first and then becoming flesh and blood."

6.18. Tipis

There are tipis in the crest in the coat of arms of the former Commissioner of the Northwest Territories, Daniel Joseph Marion. According to the Register, "the tipis are borrowed from the flag of the Tlicho Nation."

6.19. Amauti

Please see the section on Escutcheons.

7. Flora

It may seem unusual to include a flora section in this book. Envisioning a mountainous and icy region, one might not think that there is much in the way of flora to discuss and. Nothing could be further from the truth, as there is an abundance of flora in Northern Canada and it is represented in the achievements of Northern Canada.

7.1. Arctic Poppies

The heraldic blazon of the coat of arms of Nunavut describes the compartment as containing Arctic Poppies. These are small and vibrant flowers that grow in the most extreme of conditions. The Inuit refer to these flowers as *igutsat niqingit*, or "bumble-bee food," due to their popularity with the bees in the area.

7.2. Fireweed

Fireweed is a popular plant of Northern Canada and is the floral emblem of Yukon. It is a welcome sight in the spring when the fireweed begins to bloom. It can also be consumed. The heraldic blazon of the coat of arms of Nunavut describes the compartment as containing fireweed.

Fireweed is depicted in the coat of arms of the current

Commissioner of Yukon, Douglas George Phillips. The Register states that its presence there is a reference to both its status as the territorial flower and to Phillips's love of gardening.

Fireweed is depicted in the coat of arms of the former Commissioner of Yukon, Geraldine Van Bibber in the base. I assume that it represents both her attachment to Yukon, where it is the official territorial flower. It is also depicted in the compartment of the coat of arms of the former Commissioner of Yukon, Judy Gingell, for what I assume to be similar reasons.

Fireweed also makes an appearance in the compartment of the coat of arms of the former Commissioner of Yukon, John Kenneth McKinnon. Again, this is most likely an ode to his home territory.

7.3. Arctic Heather

Heather is a plant as old as time itself. It is a plant that thrives in Arctic and Northern conditions and is one of the national flowers of Norway. It is said to have been used by the Norse god Odin to treat an intestinal illness. The heraldic blazon of the coat of arms of Nunavut describes the compartment as containing Arctic Heather.

Arctic Heather is also found in the coat of arms of the former Commissioner of Nunavut, Edna Agnes Elias. The Register also mentions the usefulness of this plant as "fuel for fire."

7.4. Purple Saxifrage

Purple Saxifrage is the territorial flower of Nunavut and known to survive harsh Arctic conditions. It is also known to be the first flower that blooms in Nunavut in the springtime. The Legislative Assembly of Nunavut describes the role of the Purple Saxifrage in Inuit life in the following way: "The purple saxifrage plays a number of roles in Northern culture. The full blooming of the flowers indicated the time of year when young caribou are being born out on the land. The flowers of the purple saxifrage have a sweet taste and are eaten especially in communities where berries are not abundant."

Purple Saxifrage is found flanking the coat of arms of Nellie Taptaqut Kusugak, the current Commissioner of Nunavut. The Registrar states that the flower had been used in a commissioned painting of her mother, another tie to family.

The flower is also found in the crest of the coat of arms of the former Commissioner of Nunavut, Ann Meekitjuk Hanson. In this case, they symbolize femininity, as the Register indicates that each flower represents one of her daughters.

These flowers are also depicted in the coat of arms of the NCC Investment Group, incorporated in Iqaluit, Nunavut. Most likely it appears here as a symbol of their presence in Nunavut, as it is the territorial flower.

7.5. Mountain Avens

Mountain avens is an Arctic flower that grows in alpine regions of the world. It is the national flower of Iceland as

well as the territorial flower of the Northwest Territories. It is represented in the coat of arms of Helen Mamayaok Maksagak, the former Commissioner of the Northwest Territories, where it is displayed on the collar of the supporters to represent the holder's home territory.

Mountain avens are also featured in the crest of the coat of arms of Mark Murray De Weerdt, from Yellowknife. This was most likely a gesture to the holder's hometown.

The flower can also be found in the crest of the coat of arms of the former Commissioner of the Northwest Territories, George Lester Tuccaro. Again, this is most likely a reference to the Northwest Territories.

7.6. Clover

Flora in Northern Canadian heraldry can represent not just local plant life but also cultural heritage. This is the case with the coat of arms of the former Commissioner of Yukon, Geraldine Van Bibber. The clover in the compartment are representative of her Irish heritage. However, it can also relate to local plant life as a 2012 story reports that clover is slowly becoming an invasive species.

Clover is also depicted in the crest of the coat of arms of the former Commissioner of the Northwest Territories, Daniel Leonard Norris. This may allude to Norris's ancestry, as the crest depicts a pine marten holding a clover and a thistle.

7.7. Fleur-de-lis

The fleur-de-lis is depicted on many coats of arms in

Northern Canada and represents Francophone culture. One example of this is a fleur-de-lis on the crest as well as the arms of the coat of arms of Grégoire Daniel Cayen of Iqaluit, Nunavut. According to the register, "the cross fleury is a dual reminder of Mr. Cayen's French heritage and his abiding Christian faith."

7.8. Grass

Yukon is home to many varieties of grass. That the grasses are able to return every spring after the harsh Yukon winters is a testament to the endurance of grass. Grass is displayed in the compartment of the coat of arms of the former Commissioner of Yukon, John Kenneth McKinnon.

7.9. Arctic Cotton

Nunavut Tourism gives us the following description of the importance of this wonderful flower: this plant "blooms mid-summer at Arctic Watch, and grows in the wetter areas and swampy grounds. Once used by the Inuit as a candle wick, the cotton grass was collected, dried, and rolled to mix with seal fat in winter seal lamps. This combination of seal fat and the cotton grass wick produced a small flame, just enough to warm an igloo. In areas where caribou were in, the cotton grass wick was used in combination with caribou fat to produce a candle."

Arctic cotton is found in the coat of arms of the former Commissioner of Nunavut, Edna Agnes Elias. According to the Register, "the Arctic cotton was used as a wick in traditional seal oil lamps" and signifies the important of this plant in Inuit culture.

7.10. Arctic Draba

According to Tourism Nunavut, the Arctic draba is "a small, green, round tussock of small hairy leaves that produce clusters of yellow flowers. It is generally found on gravelled alkaline barrens." This flower can be found in the compartment of the coat of arms of the Nunasi Corporation in Iqaluit, Nunavut. According to the Register, "the Arctic draba flower is a local species" and this is probably the reason why it was included in the arms.

8. Sky Imagery

8.1. Midnight Sun

The phenomenon of extended summer nights and the "midnight sun" is exclusively part of the Northern Canadian experience. This is also captured in the achievements of Northern Canada.

The coat of arms for the Municipality of Yellowknife displays a "half-midnight sun" in the crest. The coat of arms of Nunavut also shows the midnight sun during various stages of sunrise and sunset.

The midnight sun is also depicted in the coat of arms of the former Commissioner of Yukon, Geraldine Van Bibber. In describing her coat of arms, the Register notes that the midnight sun "expresses a personality based in honesty, honour, kindness and laughter."

Four suns are also found in the coat of arms of Mark Murray De Weerdt from Yellowknife. I am assuming that it represents the holder's children as well as well as his identification with the city of Yellowknife.

There is a gold sun in the crest of the coat of arms of the

former Commissioner of the Northwest Territories, Daniel Joseph Marion. According to the Register, "the gold sun alludes to the idea of 'the land of the midnight sun.'"

8.2. Northern Lights

Another element that is uniquely Northern Canadian is the Northern Lights. As charged particles from the sun collide with the Earth's magnetosphere, a wondrous display of lights take place in the Arctic skies. This marvel is also depicted in Northern Canadian heraldry, for instance, in the multicoloured mantling in the coat of arms of the city of Whitehorse.

The Northern Lights are also depicted in the coat of arms of Yellowknife. The arms were designed by contest and the artist, Netta Pringle, used her strongest memories of the city to add elements to the shield, including the Northern Lights.

This atmospheric phenomenon is also depicted in the coat of arms of the NCC Investment Group, incorporated in Iqaluit, Nunavut. The blue and while vertical bars are meant to represent the Northern Lights according to the register.

A pattern of vertical bars representing the Northern Lights is present in the coat of arms of Nunasi Corporation in Iqaluit, Nunavut.

8.3. Azure Tincture (Blue Colour)

In the coat of arms of the former Commissioner of Yukon, Geraldine Van Bibber, the azure tincture "indicates the sky colour in Yukon, part of the Land of the Midnight Sun,"

according to the Register. An azure tincture is also used in the coat of arms of the former Commissioner of Nunavut, Peter Irniq. The blazon refers to the arms as "Azure an inuksuk, in dexter chief an Inuit drum and beater in saltire Or." While the blazon provides no reason for its use, it may be assumed that it represents the northern sky.

8.4. North Star

Please see the section on Guidance.

9. Mottos

Mottos in Northern Canadian heraldry and can be written in many languages, such as English, Inuktitut, Inuvialuktun, Southern Tutchone, and Scots Gaelic. Echoing the symbolism of many of the motifs in the section on Indigenous Elements, mottos in Northern Canadian heraldry often emphasize community or family.

9.1. Nunavut, Our Strength

The motto in the coat of arms of Nunavut is written in Inuktitut. In Latinized Inuktitut the motto reads "Nunavut Sannginivut," which translates in English to "Nunavut, Our Strength."

9.2. Many Things in a Small Place

The coat of arms for the Municipality of Yellowknife is inscribed with the Latin motto "Multum in Parvo," or "Many Things in a Small Place." The history of this motto is a unique insofar as it was selected by contest. The motto's author is Ted Horton (then editor of *News North*).

9.3. Love, Family, Tenacity

The motto used by Nellie Taptaqut Kusugak, the current Commissioner of Nunavut, is written in Inuktitut and

translates to "Love, Family, Tenacity," according to the Register.

9.4. I Will Show the Way

The motto used by Helen Mamayaok Maksagak, the former Commissioner of the Northwest Territories appears on her achievement in Latinized Inuvialuktun. It translates in English to "I Will Show the Way." According to the Register, this is "a phrase chosen to reflect Commissioner Maksagak's mission and determined spirit. It also refers to the purpose of the Inukshuk in the shield." The *inukshuk* is a symbol of guidance, as I have described in the section on Guidance.

9.5. Family is the Bedrock

The motto on the coat of arms of the current Commissioner of Yukon, Douglas George Phillips, is a Scots Gaelic phrase, "'S E CALADH AN TEAGHLACH," which translates into English as "Family is the Bedrock." I assume that this ties into both Phillips's love of family and the natural bedrock of the Yukon terrain.

9.6. Laughter Heals All

The motto on the coat of arms of the former Commissioner of Yukon, Geraldine Van Bibber, is in English and states "Laughter Heals All." No description is given in the Register as to why this motto was used or its significance to the Bibber.

9.7. Weaving for a Better Tomorrow

The motto used on the coat of arms of the former

Commissioner of Yukon, Judy Gingell, is written in Southern Tutchone, and means "Weaving for a Better Tomorrow."

9.8. Fortune Favours the Bold

Southern Tutchone is also the language used to express the motto on the coat of arms of the former Commissioner of Yukon, John Kenneth McKinnon. As inscribed, the motto reads "NÄNÀTSÄT TS'AN LÈKHEL KWÄŁÈ," which translates in English to "Fortune Favours the Bold."

9.9. Perseverance, Commitment, Service

The motto on the coat of arms of the former Commissioner of the Northwest Territories, Anthony Wilfred James Whitford is written in English as "Perseverance, Commitment, Service." According to the Register, "'Perseverance' relates to overcoming obstacles; 'Commitment' to family, friends, and community; and 'Service' to helping and caring for those in need. The Métis sash bearing the motto represents the heritage of Mr. Whitford."

9.10. Never Say Die

The motto on the coat of arms of the former Commissioner of the Northwest Territories, Glenna Fanny Hansen, is written in English as "Never Say Die." According to the Register, "This expression of determination is also the motto of Commissioner Hansen's birthplace, Aklavik."

9.11. Born to Soar

The motto on the coat of arms of the former Commissioner

of the Northwest Territories, Daniel Leonard Norris, is written in English as "Born to Soar."

9.12. Co-operation Enhances Peace

The motto of the coat of arms of the former Commissioner of Nunavut, Ann Meekitjuk Hanson is written bilingually in both English and Inuktitut of "Co-operation Enhances Peace." According to the Register, "This indicates the importance that co-operation played in the survival of the Inuit in harsh natural conditions, a way of life that continues in the present-day approach to consensus government and administration."

9.13. Let Us Move Forward

The motto on the coat of arms of the former Commissioner of Nunavut, Peter Irniq, is also expressed bilingually. The motto, meaning "Let us Move Forward," is also found in Inuinnaqtun and Inuktitut.

9.14. Let Right Be Done

Mottos are also expressed in French. The coat of arms of Mark Murray De Weerdt from Yellowknife features the motto, "Soit droit fait," or the "Let Right Be Done." This is also the motto of the Faculty of Law at Queen's University. According to Queen's Faculty of Law, "'Soit droit fait' (Let law be made/Let right be done), the Faculty motto, is adapted from Norman French, and symbolizes the concept of the rule of law—the democratic ideal of government under just laws—and the dynamic tension between the two sides of law, one side creating the rules that govern our society, and the other side ensuring that these rules result in

the greatest common good."

9.15. Healing One Heart at a Time

The motto on the coat of arms of the former Commissioner of the Northwest Territories, George Lester Tuccaro, is written in English. According to the Register, "'Healing One Heart at the [*sic*] Time' expresses the idea that a community is healed one heart at a time."

9.16. Nurture Hope

The motto on the coat of arms of the former Commissioner of the Northwest Territories, Daniel Joseph Marion, is "Nurture Hope." The Register provides no explanation as to the meaning of this motto.

9.17. My Past Guides My Future

The motto on the coat of arms of the former Commissioner of Nunavut, Edna Agnes Elias, is written in Inuinnaqtun and translates in English to "My Past Guides My Future," according to the Register.

9.18. Creating Opportunities

The motto of the coat of arms of the Nunasi Corporation in Iqaluit, Nunavut, is written in Inuktitut and means "Creating Opportunities."

10. Tinctures

10.1. Copper

The coat of arms of Whitehorse contains a tincture of a copper colour to represent the importance of the copper industry in the region as well as its use by Indigenous groups. This is the first time that the metallic tincture of copper was added to a Canadian coat of arms.

10.2. Establishments

Tinctures can also represent establishments in Northern Canada. According to the Register for the coat of arms of Nellie Taptaqut Kusugak, the current Commissioner of Nunavut, "the blue, red and yellow refer to the service of Commissioner Kusugak's father in the Royal Canadian Mounted Police, the uniform of which uses these colours."

A tincture of blue, red and yellow is also found in the coat of arms of the former Commissioner of the Northwest Territories, George Lester Tuccaro. According to the Register, "the blue, red and yellow colours are taken from the coat of arms and the flag of the Northwest Territories, of which Mr. Tuccaro is Commissioner."

The tincture of white and yellow is used in the coat of arms of Grégoire Daniel Cayen of Iqaluit, Nunavut. According to the Register these tinctures were used as they are the colours of the flag of Nunavut.

10.3. Or

Gold is a popular tincture due to the abundance of the natural resource in the region. Please refer to the entry for Gold in the section on Minerals for more information on how gold is represented in Northern Canadian heraldry.

10.4. Azure

Azure can be used to represent the sky. Please read the entry on Azure Tincture in the section on Sky Imagery for more information.

11. Final Thoughts

When examining the various components of and symbolism in Northern Canadian heraldry, one cannot help but note the emphasis on family and community. There is also a deep symbolic emphasis on guidance. I believe that the two themes are intertwined. Heraldry in Northern Canada seems to tell a story about how the community can help guide others and "weave for a better tomorrow," to paraphrase the motto of the former Commissioner of Yukon, Judy Gingell. My hope for this book is to promote and educate others on the culture of Northern Canada as represented in its heraldry. Its symbolism and message can be a guide for all of us to learn from our past and guide our future, to paraphrase the motto of the former Commissioner of Nunavut, Edna Agnes Elias.

Bibliography

Aiken, S. G., Dallwitz, M. J., Consaul, L. L., McJannet, C. L., Boles, R. L., Argus, G. W.,. . . Harris, J. G. (2007). Flora of the Canadian Arctic Archipelago: Descriptions, Illustrations, Identification, and Information Retrieval. Ottawa: National Research Council of Canada. Retrieved from https://nature.ca/aaflora/data

Appleton, David P. (2002). New Directions in Heraldry [But there really is 'nothing new under the sun]. Retrieved from http://www.baronage.co.uk/2002d/appleton.pdf

Blubber Lamps. (2003).PRISM: Polar Radar for Ice Sheet Measurements. Retrieved from http://ku-prism.org/quicktimeVR/Websites/Blubberlamps.html

Canadian Wildlife Federation. (n.d.). Grizzly Bear. *Hinterland Who's Who*. Retrieved from http://www.hww.ca/en/wildlife/mammals/grizzly-bear.html

Canadian Wildlife Federation. (n.d.). Marten. *Hinterland Who's Who*. Retrieved from http://www.hww.ca/en/wildlife/mammals/marten.html

Canadian Wildlife Federation. (n.d.). Ptarmigan. *Hinterland Who's Who*. Retrieved from http://www.hww.ca/assets/pdfs/factsheets/ptarmigan-en.pdf

CBC News. (2012, August 3). Sweet clover invades Yukon's roadsides. Retrieved from https://www.cbc.ca/news/canada/north/sweet-clover-invades-yukon-s-roadsides-1.1272633

City of Yellowknife. (n.d.). Trademarks: Official City of Yellowknife Crest. Retrieved from https://www.yellowknife.ca/en/Trademarks.asp

Data Analysis Center for Geomagnetism and Space Magnetism, Kyoto University. (n.d.). Magnetic North, Geomagnetic and Magnetic Poles. Retrieved from http://wdc.kugi.kyoto-u.ac.jp/poles/polesexp.html

Driscoll, Bernadette. (1984). Sapangat: Inuit Beadwork in the Canadian Arctic. *Expedition*. Retrieved from https://www.penn.museum/documents/publications/expedition/PDFs/26-2/Driscoll.pdf

Editors of Encyclopedia Britannica. (n.d.). Alaskan Malamute. In *Encyclopedia Britannica*. Retrieved from https://www.britannica.com/animal/Alaskan-Malamute

Faculty of Law., Queen's University. (n.d.). History. Retrieved from https://law.queensu.ca/about/history

Fisheries and Oceans Canada. (2014, March 11). Arctic Char. Retrieved from http://www.dfo-mpo.gc.ca/fm-gp/sustainable-durable/fisheries-peches/char-omble-eng.htm

Freeman, Na'ama (2016, February 15). Symbolism in Inuit tattooing: *First Peoples, First Screens* crafts, spaces for conversation." *The McGill Daily*. Retrieved from https://www.mcgilldaily.com/2016/02/symbolism-in-inuit-tattooing/

Government of Canada. (2018, September 19). Wood Bison. *Species at Risk Public Registry*. Retrieved from http://www.sararegistry.gc.ca/species/speciesDetails_e.cfm?sid=143

Government of Canada. (2018, June 6). Maps of subpopulations of polar bears and protected areas. Retrieved from https://www.canada.ca/en/environment-climate-change/services/biodiversity/maps-sub-populations-polar-bears-protected.html

Government of Yukon. (2016, May 26). Emblems and Symbols. Retrieved from https://www.gov.yk.ca/aboutyukon/emblemsandsymbols.html

Governor General of Canada. (n.d.). *The Canadian Heraldic Authority*. Retrieved from

https://www.gg.ca/en/heraldry/canadian-heraldic-authority

Governor General of Canada (n.d.). *Public Register of Arms, Flags and Badges of Canada*. Retrieved from https://www.gg.ca/en/heraldry/public-register-arms-flags-and-badges-canada

Handford, Jenny Mai. (1998). Dog Sledging in the Eighteenth Century: North America and Siberia. *Polar Record*, 34(190), 237-248. Retrieved from https://doi.org/10.1017/S0032247400025705

Heritage Canada (2017, August 15). Northwest Territories' Territorial Symbols. Retrieved from https://www.canada.ca/en/canadian-heritage/services/provincial-territorial-symbols-canada/northwest-territories.html

Heritage Canada (2017, August 15). Yukon's Territorial Symbols. Retrieved from https://www.canada.ca/en/canadian-heritage/services/provincial-territorial-symbols-canada/yukon.html#a3

Legislative Assembly of Nunavut. (n.d.). The Mace of Nunavut. Retrieved from https://www.assembly.nu.ca/about-legislative-assembly/mace-nunavut

Legislative Assembly of Nunavut. (n.d.). The Official Flower of Nunavut. Retrieved from https://www.assembly.nu.ca/about-legislative-

assembly/official-flower-nunavut

National Audubon Society. (n.d.). Guide to North American Birds. Retrieved from https://www.audubon.org/field-guide/bird

National Geographic. (n.d.). Ringed Seal. Retrieved from https://www.nationalgeographic.com/animals/mammals/r/ringed-seal/

Native Drums. (n.d.). An Inuit Drum. Retrieved from http://native-drums.ca/en/drumming/an-inuit-drum/

Nunavut Tourism. (n.d.). The Beautiful Flowers of the Arctic. *Travel Nunavut*. Retrieved from https://www.nunavuttourism.com/the-beautiful-flowers-of-the-arctic/

NWT Species at Risk. (n.d.). Whooping Crane. Retrieved from https://www.nwtspeciesatrisk.ca/content/nwt-whooping-crane

Rogers, Kara. (2005, September 27). The Legend and Mystery of the Narwhal [Blog post]. Retrieved from http://blogs.britannica.com/2011/03/legend-mystery-narwhal/

Royal Canadian Geographic Society. (n.d.). Animal Facts: Walrus. *Canadian Geographic*. Retrieved from https://www.canadiangeographic.ca/article/animal-facts-walrus

Royal Heraldry Society of Canada. (n.d.). *The Royal Heraldry Society of Canada*. Retrieved from

https://www.heraldry.ca/main.php?LANG=en

Ryder, Kassina. (2017, June 12). Anatomy of an Amauti. *Up Here Magazine*. Retrieved from https://uphere.ca/articles/anatomy-amauti

Statistics Canada (2005, February 1). Land and Freshwater Area, by Province and Territory. Retrieved from https://web.archive.org/web/20110524063547/http://www40.statcan.gc.ca/l01/cst01/phys01-eng.htm

Statistics Canada (2010, December 6). 2006 Aboriginal Population Profile. Retrieved from https://www12.statcan.gc.ca/census-recensement/2006/dp-pd/prof/92-594/details/page.cfm?Lang=E&Geo1=PR&Code1=60&Geo2=PR&Code2=01&Data=Count&SearchText=Yukon+Territory&SearchType=Begins&SearchPR=01&B1=All&Custom=

Statistics Canada (2018, February 8). Population and Dwelling Count Highlight Tables, 2016 Census. Retrieved from https://www12.statcan.gc.ca/census-recensement/2016/dp-pd/hlt-fst/pd-pl/Table.cfm?Lang=Eng&T=101&S=50&O=A

Tlingit Haida Tribal Business Corporation. (n.d.). About Us. Retrieved from https://www.thtbc.com/about/

Wonders, William C. (2018, October 10). Yukon. *The Canadian Encyclopedia*. Retrieved from https://www.thecanadianencyclopedia.ca/en/article/yukon

World Wildlife Federation. (n.d.). Bowhead Whale: Giants of the Arctic. Retrieved from http://www.wwf.ca/conservation/arctic/wildlife/bowhead_whale/

Yukon Conservation Data Centre. (2012, May). Rare Plant Information Sheets. Retrieved from http://www.env.gov.yk.ca/animals-habitat/documents/selkirk

Yukon Department of the Environment. (2018, January 22). American Marten. Retrieved from http://www.env.gov.yk.ca/animals-habitat/mammals/marten.php

Yukon Department of the Environment. (2018, December 24). Dall's Sheep. Retrieved from http://www.env.gov.yk.ca/animals-habitat/mammals/sheep.php

www.ingramcontent.com/pod-product-compliance
Lightning Source LLC
Chambersburg PA
CBHW031925170526
45157CB00008B/3057